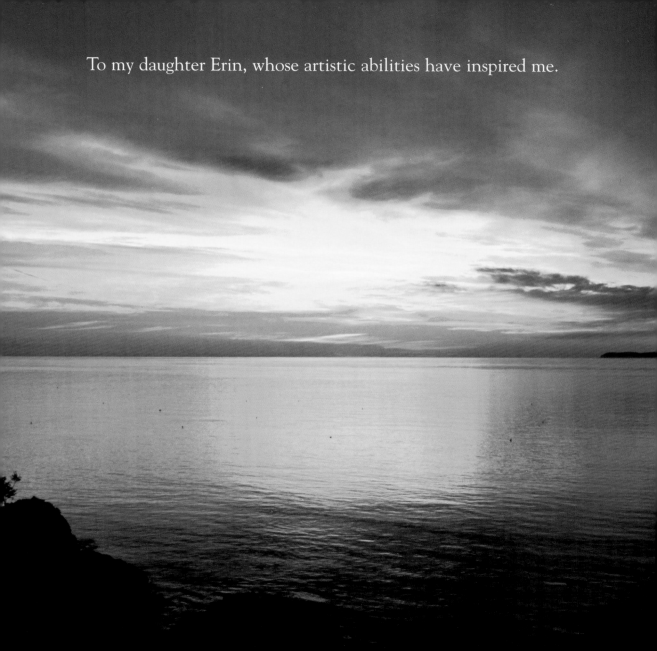

To my daughter Erin, whose artistic abilities have inspired me.

Foreword

There are many sides to Maine. There are, of course, left sides and right sides, upsides and downsides, insides and outsides. There are also bedsides, countrysides, and something on the side. Which brings to mind the sides that come with a lobster dinner—corn on the cob and melted butter, which dribbles down your front side and enlarges your backside

For people who enjoy the outdoors, there are more important sides of Maine—hillsides, seasides, lakesides, riversides, trailsides, roadsides, harborsides, and mountainsides. These are the sides where the full-time residents, part-time summer folk, and have-no-time weekenders spend as much of their time as possible. And who can blame them? In large part, these features are what make this far corner of America so compelling and beautiful.

These are also the sides where you'll find photographer Greg Currier looking for photographs like those found in this book. At dawn or at dusk, in the fog or on a sunny summer day, Greg is out exploring all the sides of Maine. I have seen many, many pictures of Maine, more so than most people. This is because I have taught more than two hundred and fifty photography workshops over the last twenty-five years and I critique about ten thousand pictures every year. That's a lot of pictures! I have seen pictures from everywhere in the world where pictures are taken. It feels like not only I have been to all these places, but I know each one intimately.

This certainly applies to Maine. I have been coming to Maine for many years and have taught there and photographed it many times; it remains one of my favorite places to linger and explore. And I thought I knew the state intimately until I saw the photos in this wonderful book. But how can I claim intimacy when I had overlooked such a pretty and obvious part of Maine?

Reflections
OF Maine

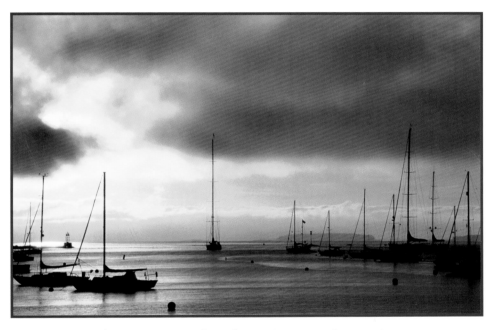

Photographs by Greg Currier

Foreword by David Middleton

Down East

ISBN (13-digit): 978-0-89272-771-1

Library of Congress Cataloging-in-Publication Data

Currier, Greg, 1947–
Reflections of Maine / photographs by Greg Currier ; foreword by David Middleton.
p. cm.
ISBN-13: 978-0-89272-771-1 (trade hardcover)
1. Maine--Pictorial works. 2. Landscape--Maine--Pictorial works. I. Title.
F20.C87 2008
974.1'0440222--dc22
2007050689

Design concept: Chilton Creative
Printed in China

2 4 5 3 1

Distributed to the trade by National Book Network
www.downeast.com

I can't, but Greg Currier can. He has seen beauty in the unnoticed and ordinary and turned the everyday into the extraordinary. His photographs (these are not just pictures!) celebrate what most of us ignore or never even see prodding us to slow down and look for and then admire what we have been missing. That's the flipside of Maine, the side of Greg Currier's images that I most enjoy. I hope you will as well.

—David Middleton

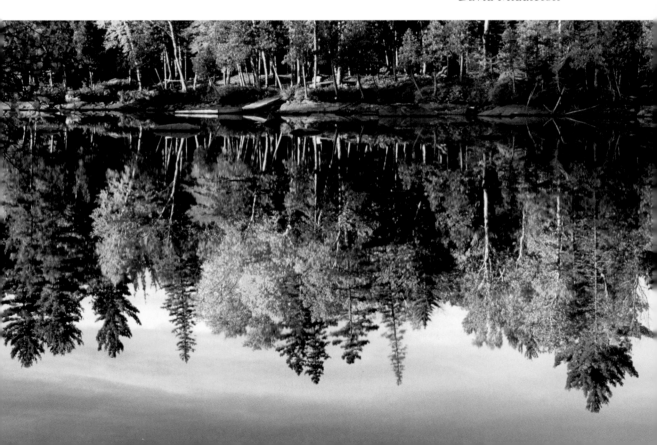

Preface

What draws me to study the images created by reflective surfaces is the joining of two disparate subjects by a trick of nature. The mountain reflected in a still lake at dawn or dusk is a classic example of a reflection enhancing the appeal of a photograph. Reflections also add a unique element to photographs. Sometimes these images can confuse and intrigue the viewer. The image on the cover of this book is a lighthouse reflected in a tide pool. The rocks around the pool give the appearance of looking out from a cave or through a layer of ice. The viewer is surprised to learn how the unaltered photograph was taken. In another image, the reflection of a deck railing in a layer of rainwater in a dinghy echoes reflections in the harbor where the dinghy floats. The reflections in a window merge nature with the works of man. These are but a few examples of the images that await you.

This book contains images taken in Maine that are all reflections on the surface of glass, puddles, streams, ocean, etc. No creative manipulations were done to the images, and all the reflections are as I saw them, although I often had to go back to a spot many times to get it just right. I seldom use filters, and when I do it is just to remove glare or reduce contrast, not to shift the colors. Most of these images were taken with a film-based Nikon 35mm format camera, with a few taken with a Nikon DSLR.

Photographing reflections offers some unique challenges. For example, a polarizing filter will cut down the reflected image in window reflections and thereby allow more of the interior to show through. It is also important to realize where you are relative to the reflecting object so that a tripod leg doesn't end up in the photograph; move off-center to avoid this. Depth of field is also a consideration. Using an auto-focus camera might cause the surface of the reflecting layer

to be in focus but not the image reflected in it. I often disable the auto-focus or else use a higher f-stop number for a greater depth of field. This is particularly necessary when using a macro lens for close-up work, as the macro lenses have a smaller depth of field.

Reflected images in a body of water are often darker than the nonreflected image. To compensate for this situation, I use a graduated split neutral density filter. This will darken the sky and bring it in line with the intensity of the reflected image.

If you are interested in trying your hand at this type of photography, you'll need to start looking at scenes differently to discover reflections. Narrow in on a window instead of the whole building; look at the shiny brass compass instead of the entire boat; look for a puddle after a rain and explore the reflections from different angles. You might look out of place pacing around a puddle in a parking lot while others are taking pictures of the trees, but you'll get a photograph while they'll leave with just a snapshot.

One "rule" of photography is not to frame a photo so the horizon will fall at the center of the picture. At times, I like the balance in an image better when I break this rule. Be aware of what each portion of your image contains. Reflections in water can either be true to the image (as in a still lake) or add an element of mystery when the wind stirs up the surface slightly.

The best time to search for interesting reflections is in the early morning or after a rain. It is then that the light is the softest, puddles abound, dinghies are full of water, flowers or grasses still hold drops of dew, and reflected colors in any surface are the richest.

Enjoy the state of Maine from a different perspective!

—G. C.

T he first group of photographs shows bays and harbors where the water is reflecting the colors and design of the sky. In such low-angle light, sky and sea can seem to merge into one continuous color.

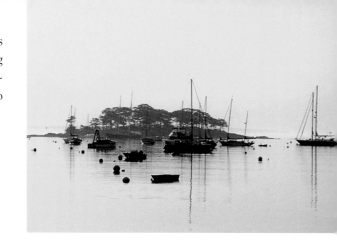

Camden Harbor on a calm spring afternoon

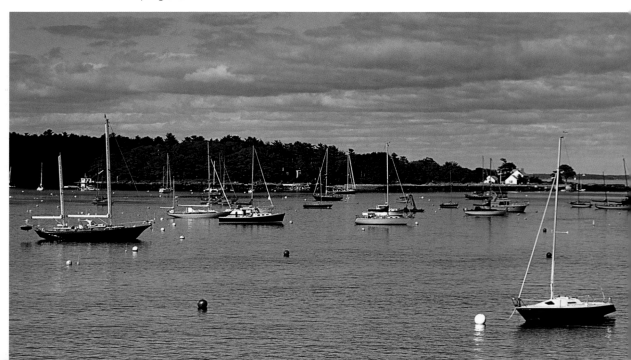

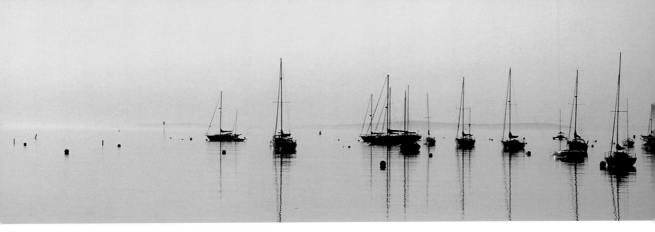

On a sultry summer morning, reflections of masts sketch delicate lines on the harbor's surface.

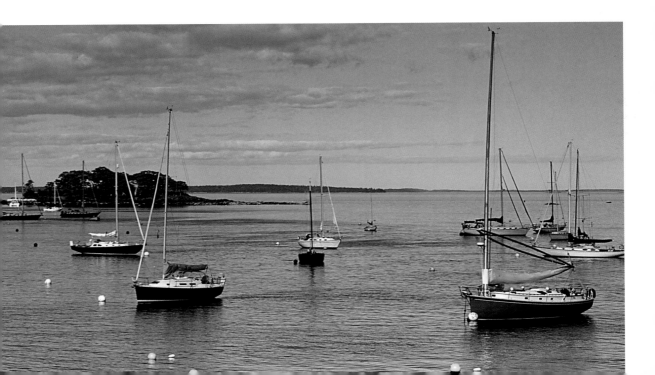

Distant Islesboro and North Haven islands are all that define the horizon in this view.

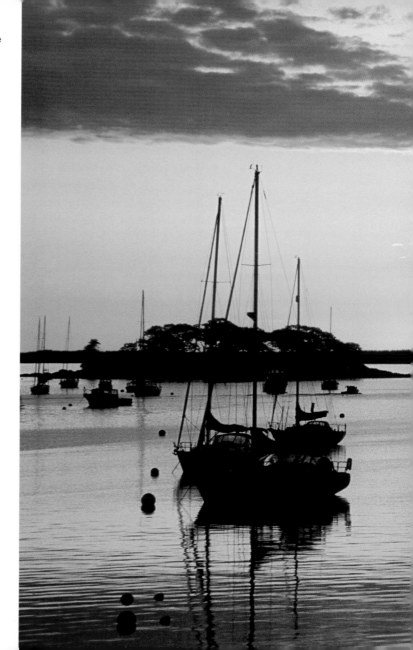

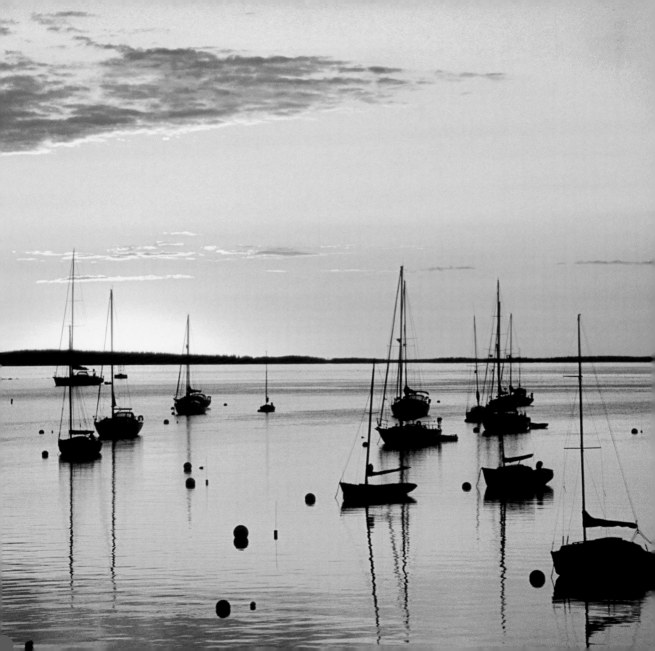

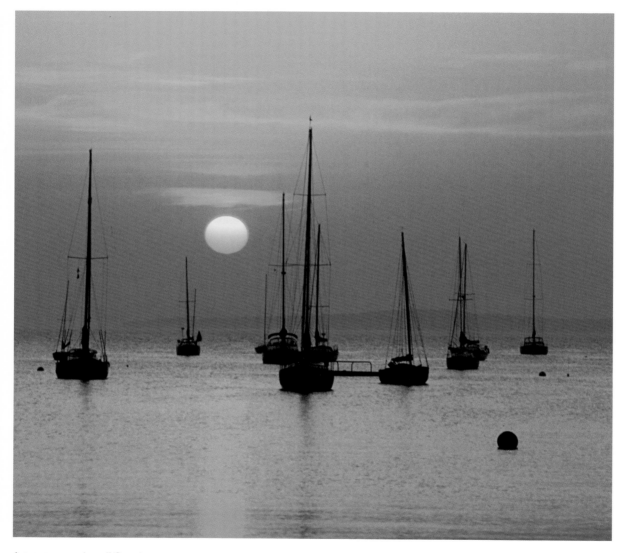

A summer sunrise off Camden

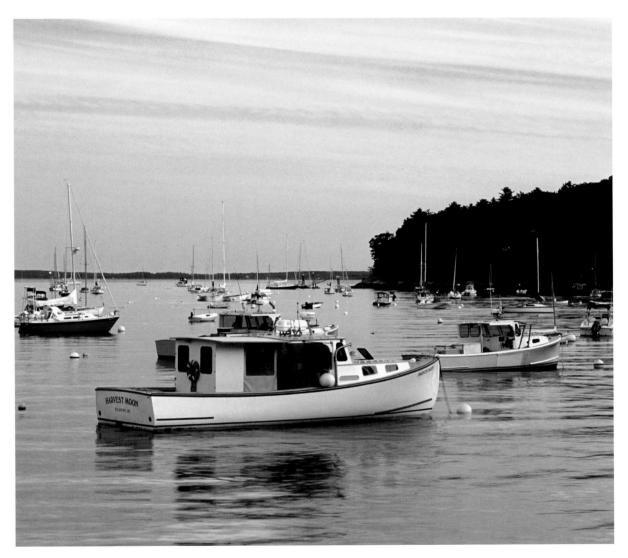

The unique soft color of a sunset sky appears deeper and brighter in the waters of Rockport Harbor.

13

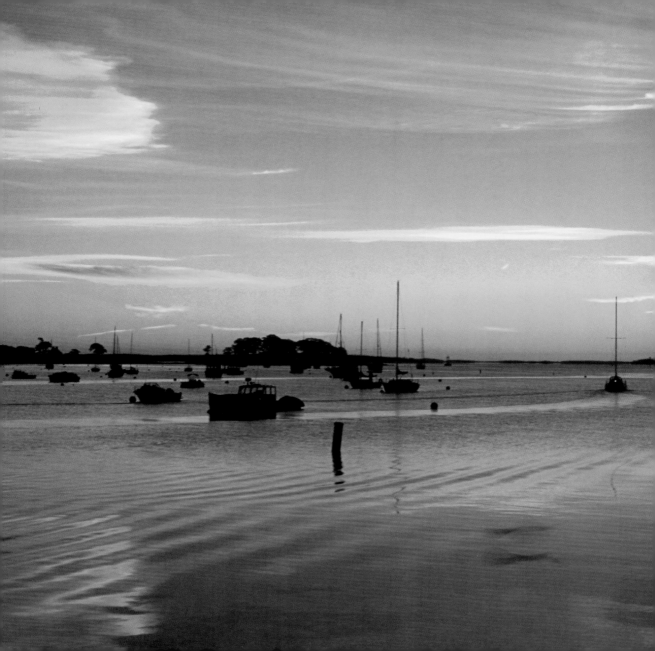

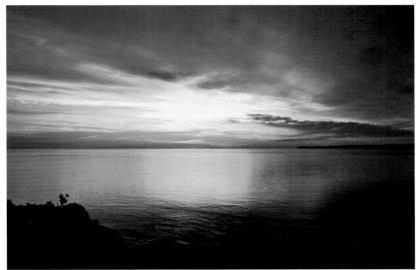

Sunrise over Cobscook Bay in far down east Maine

A wide-angle shot was required to capture these clouds
brush-stroked across a dawn sky.

The complex reflections seen on moving water are always fascinating. The distortion of the image caused by the irregular surface can add an ethereal quality.

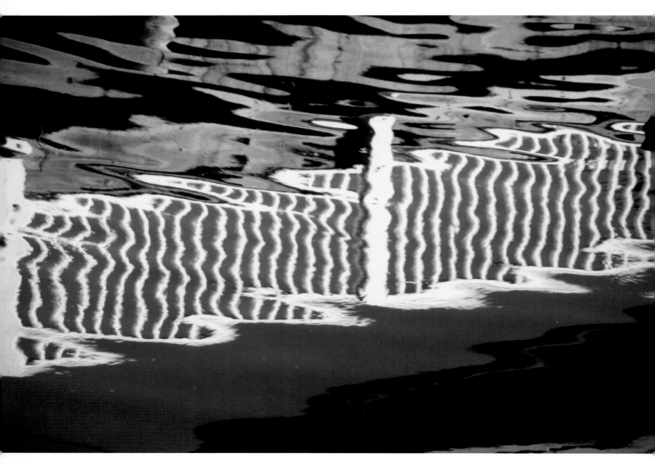

Reflected railings offer a study in bold juxtaposition of colors.

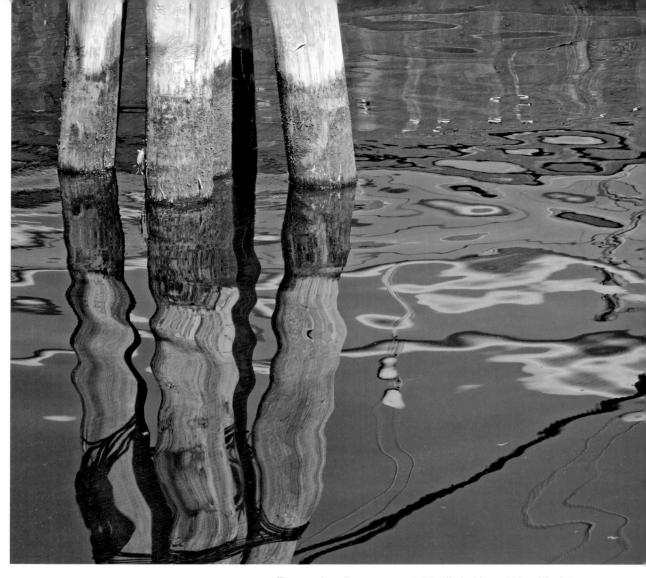

The wooden pilings are easy to identify, but it would be difficult to guess that the bright shapes behind are reflections of a boat's furled sail.

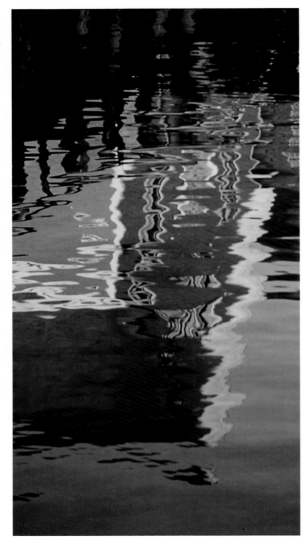

Dockside buildings in Port Clyde

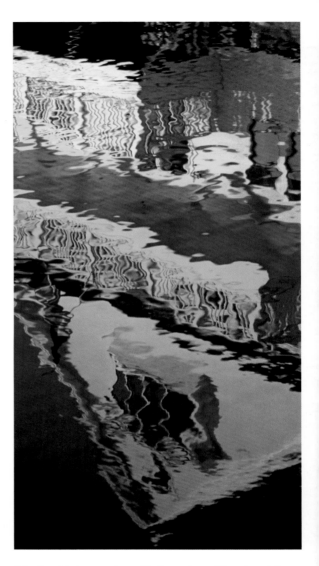

A harborside home mirrored in the waters of Penobscot Bay

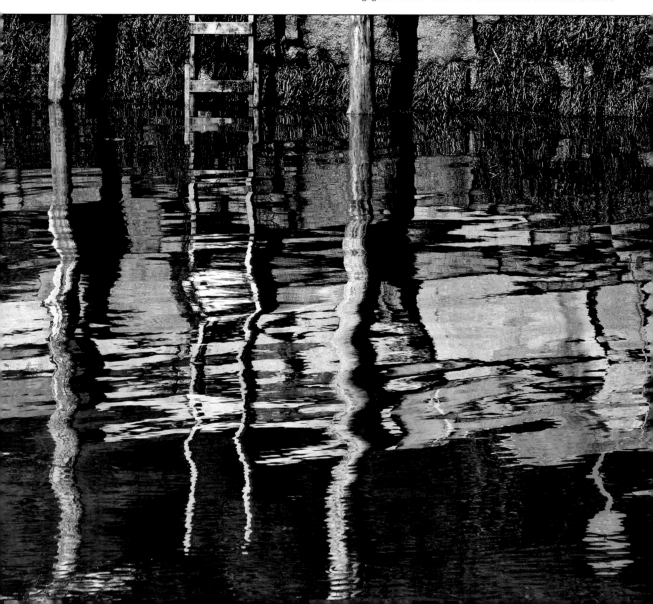

A looking-glass ladder seems to lead in both directions at once.

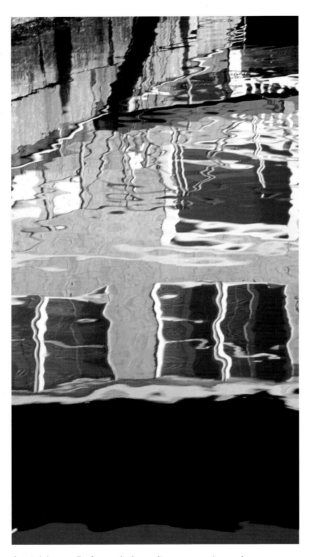

A retaining wall of quarried granite appears to anchor
this building's reflection.

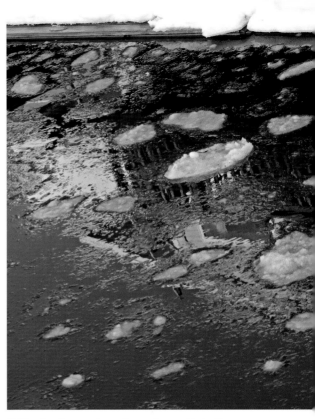

Drifting ice fragments on the surface add depth
to the reflected image.

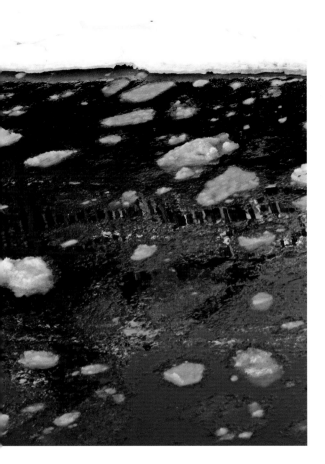

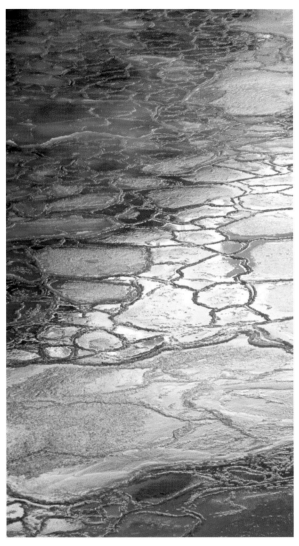

Ice offers a gentle, muted reflection of winter sun illuminating nearby buildings.

21

The reflections of boat hulls and masts in a still harbor are a natural for any photographer of the Maine coast. Concentrating on the reflected image as opposed to the boat gives a different dimension to the images.

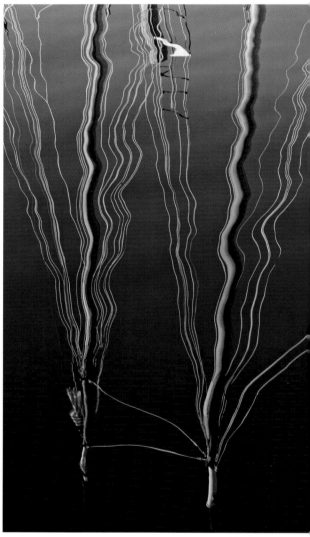

A Camden Harbor lobster boat

Masts of a yacht in Boothbay Harbor

A sailboat hull at Bar Harbor

River currents ripple the surface, softening reflections of colorful dinghies. Where a freshwater river enters the harbor, the water is never entirely still.

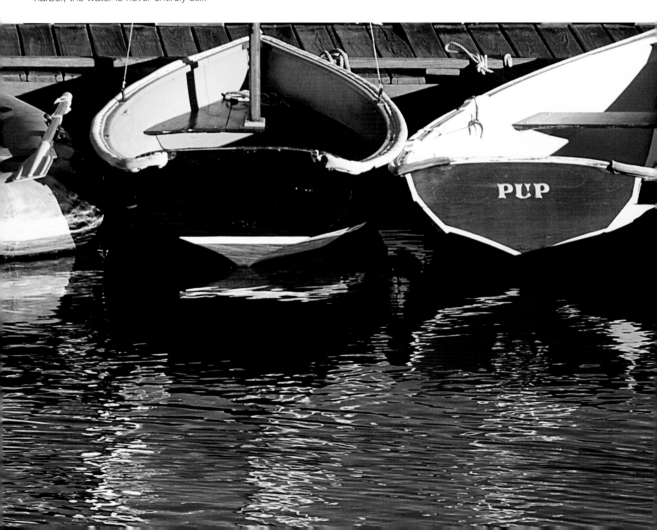

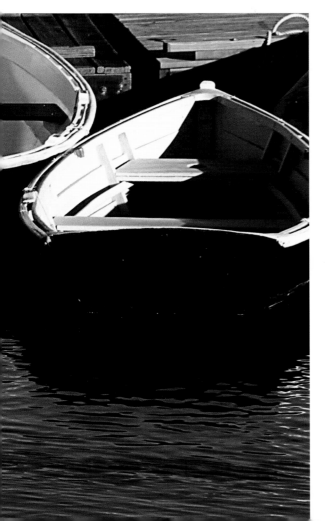

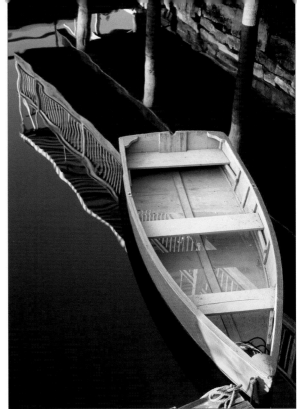

Floating on one mirrored surface, a small skiff contains its own, smaller reflective pool.

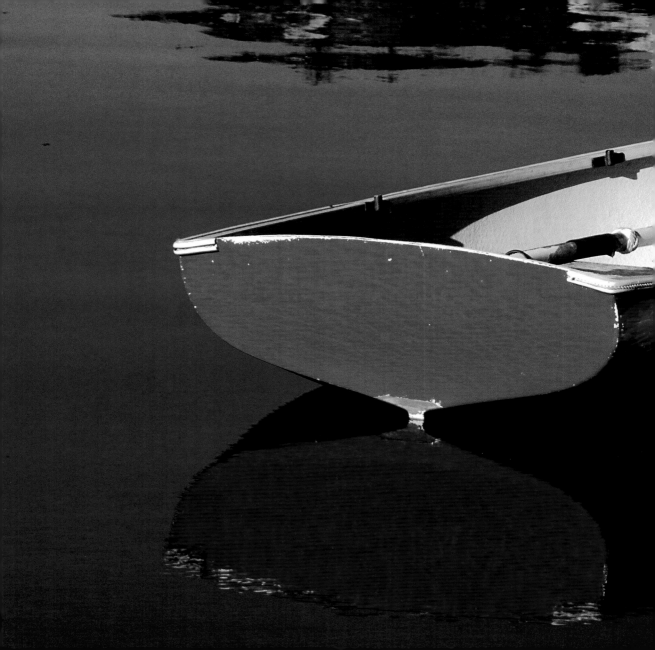

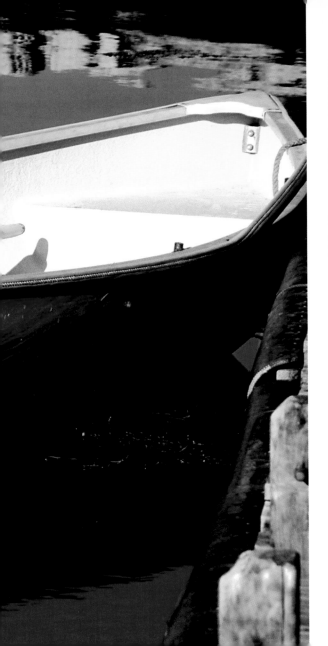

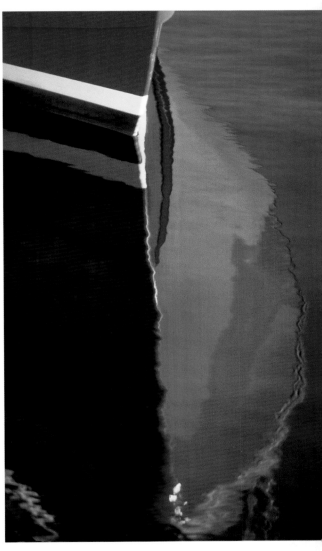

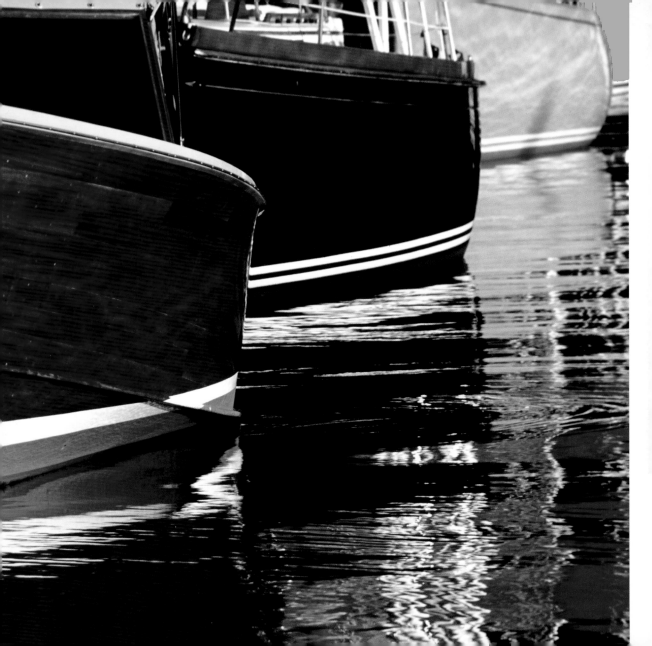

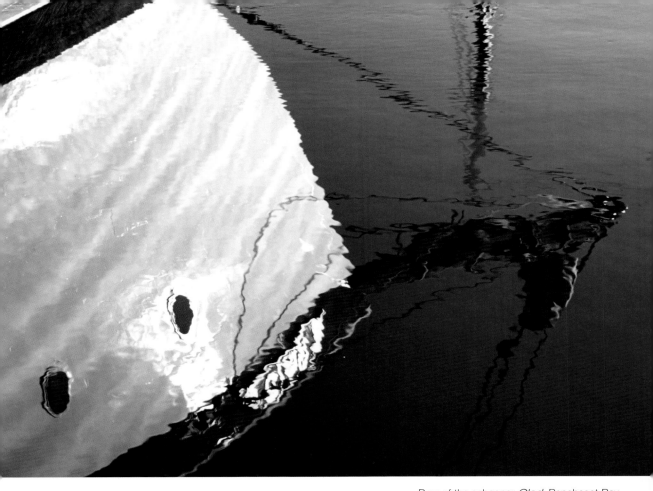

Bow of the schooner *Olad*, Penobscot Bay

Tied up for the night, Camden Harbor

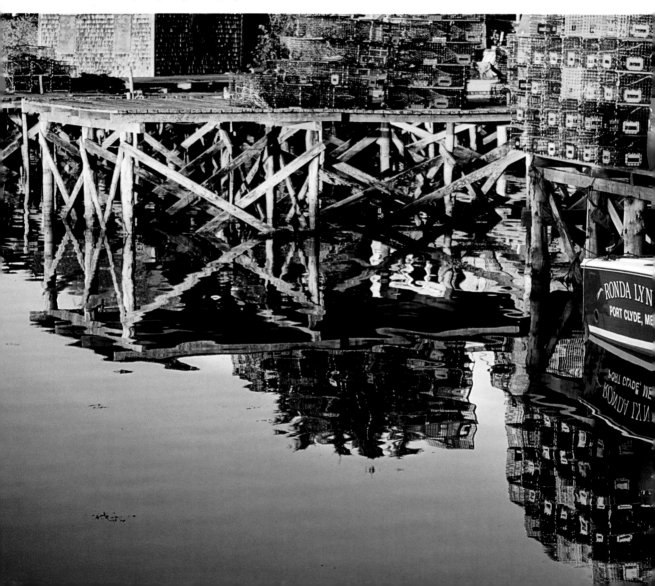

W orking gear and wharves add their own geometry in
the next group of photographs.

Lobster traps at Port Clyde

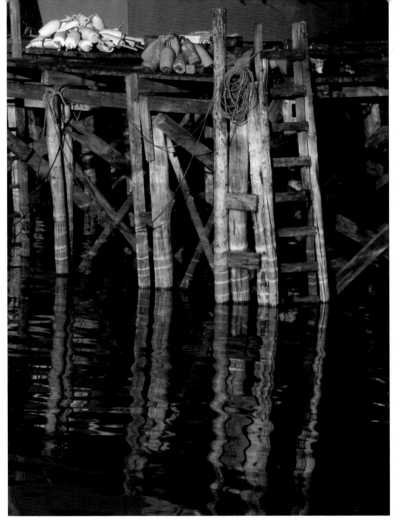

Buoys on a wharf at Owls Head

R eflected hills frame winter and spring views of the harbor
at Camden, "where the mountains meet the sea."

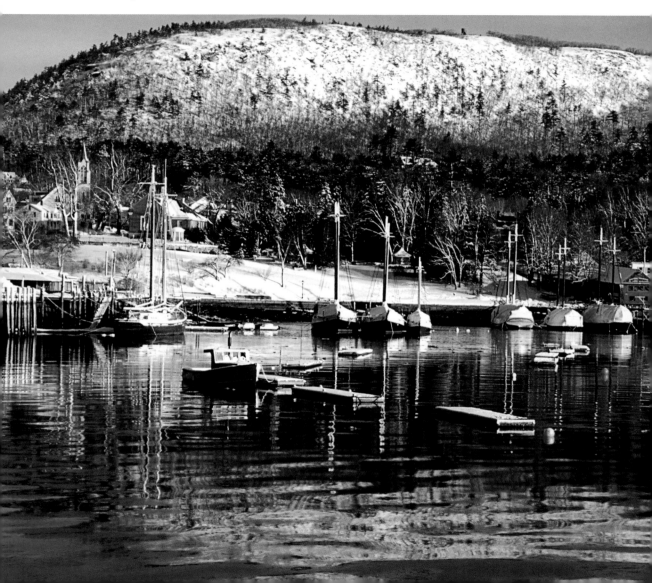

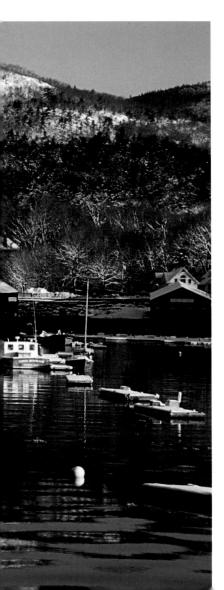

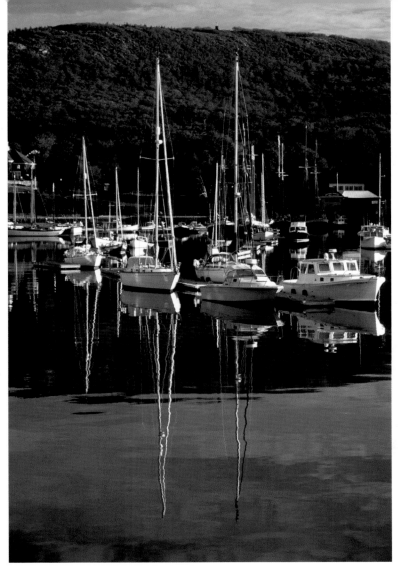

W indows are particularly interesting subjects because items on the other side of the glass blend with the reflected outdoor background. Weathered window frames and old, wavy glass add to the visual appeal.

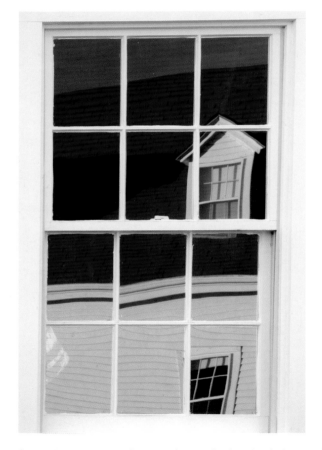

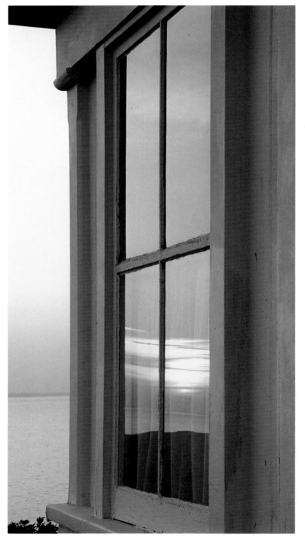

Sunset brings a touch of warm color to reflections in windows at the Monhegan Museum.

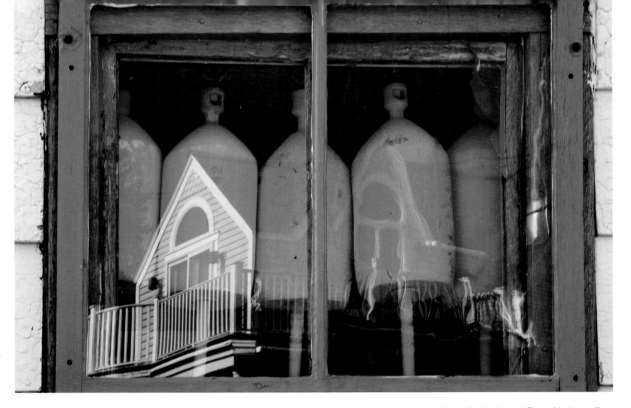

A small window at Bass Harbor offers
an interesting perspective.

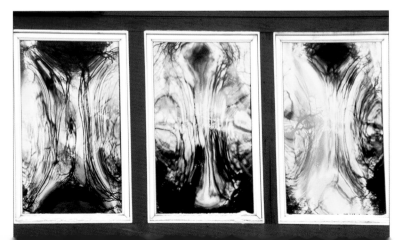

Sunrise triptych

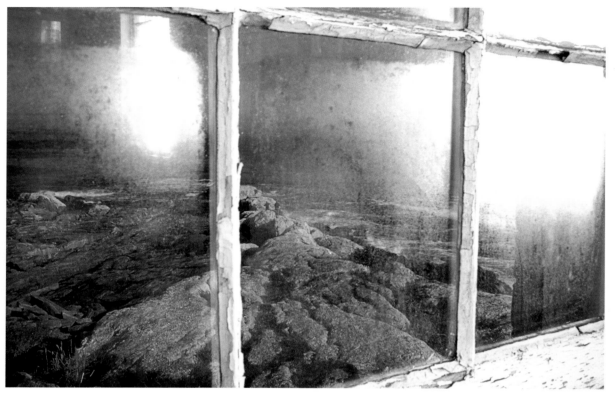

Pemaquid's famed rocks and surf reflected
in the lighthouse station's bell-house window

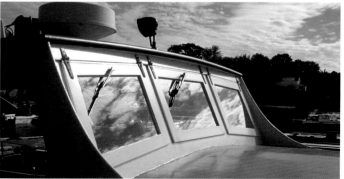

The windshield of a lobster boat reflect layers
of clouds against a bright sky.

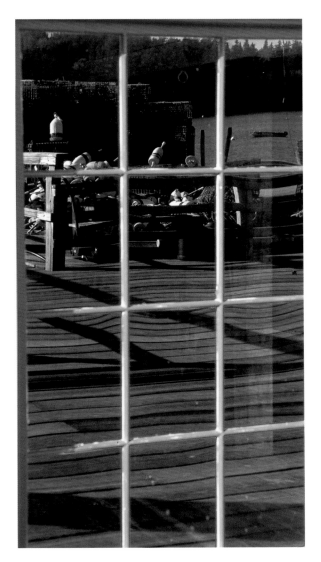

On the dock at Tenants Harbor

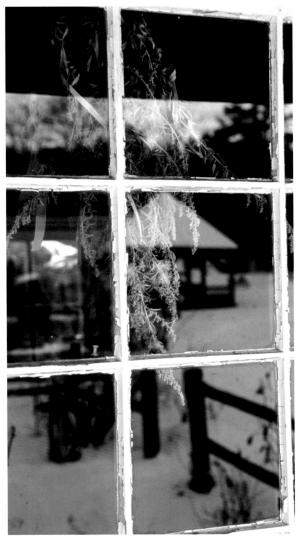

Camden's Merryspring Nature Center gardens in winter

A window in Boothbay Harbor reflects the receding winter.

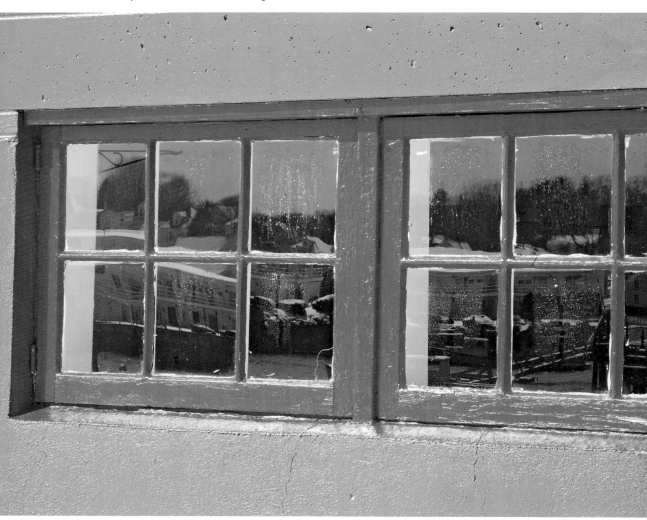

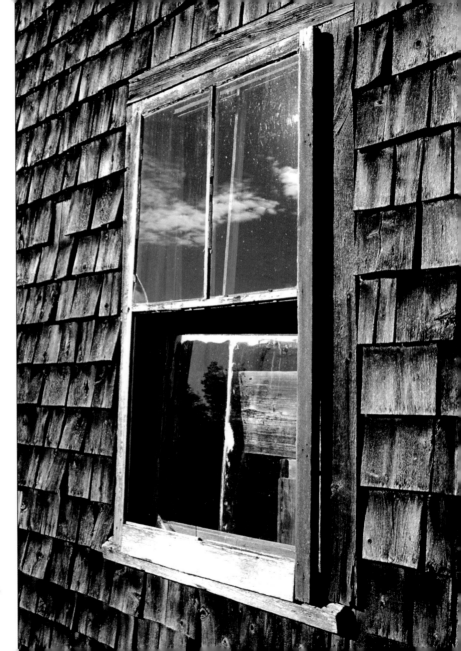

The window of an abandoned house
still catches a bit of sky.

W ith the next group of photographs, we move inland. Lakes and calm rivers provide a still environment for mirrorlike reflections whose perfection captures our gaze.

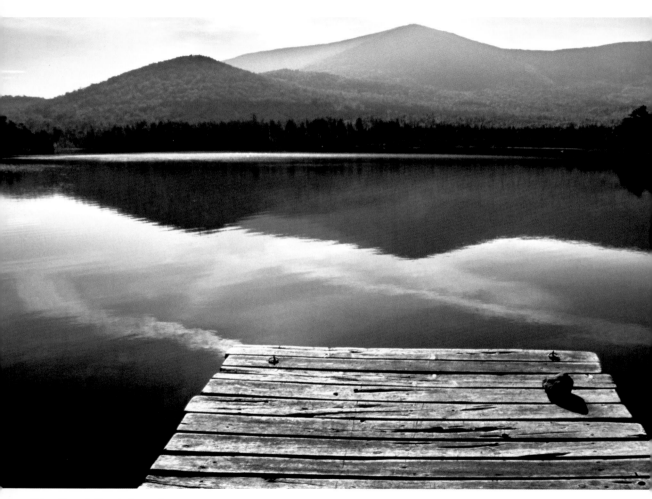

West Branch Pond, Greenville

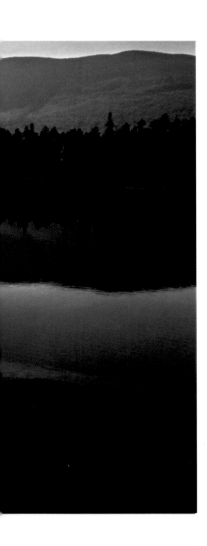

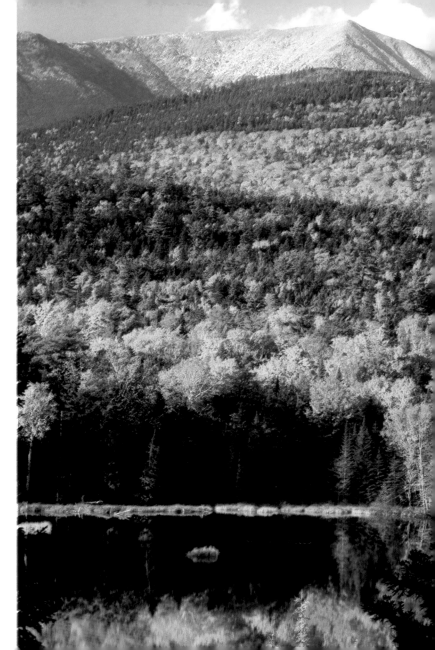

Fall comes to Baxter State Park.

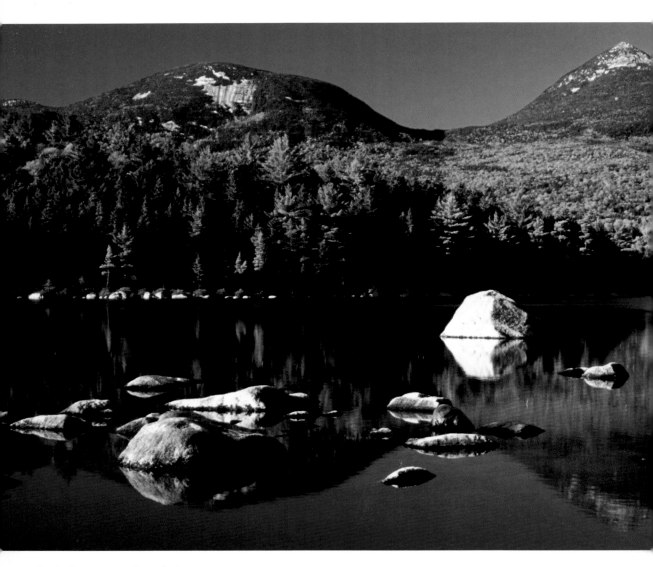

Rocky Pond, Baxter State Park

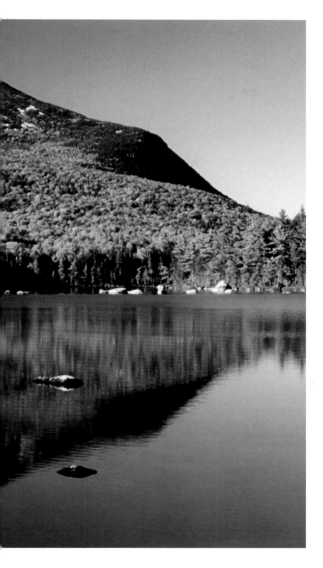

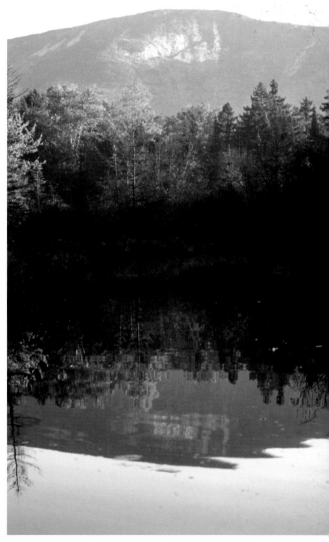

Kidney Pond, Baxter State Park, on a fall morning

43

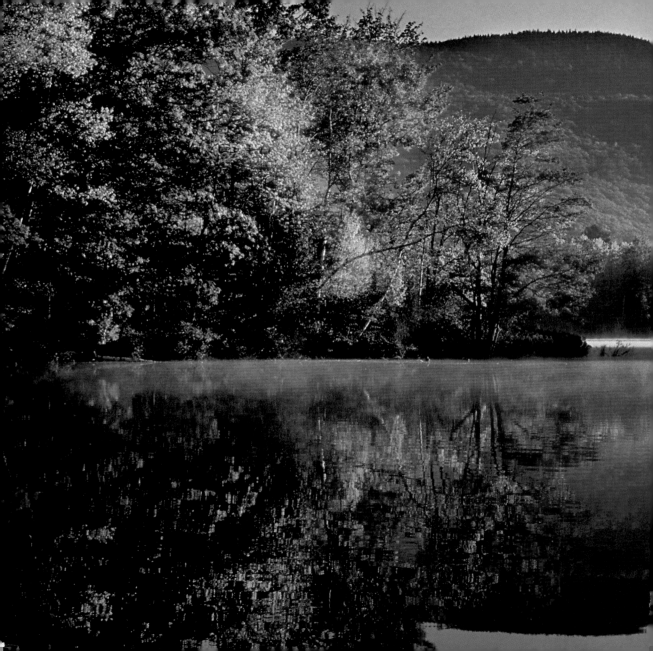

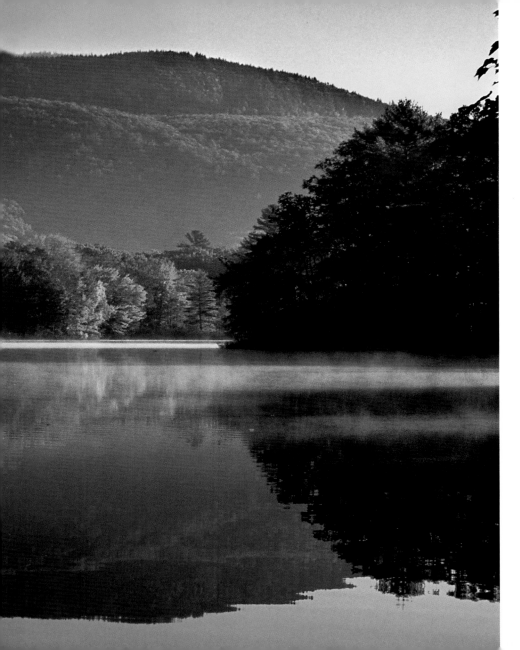

Fall on the
Megunticook River
in Camden

45

L akes and streams are only occasionally mirrorlike. When a light breeze ripples the surface or the current flows among rounded stones, colors become mingled in a rich tapestry.

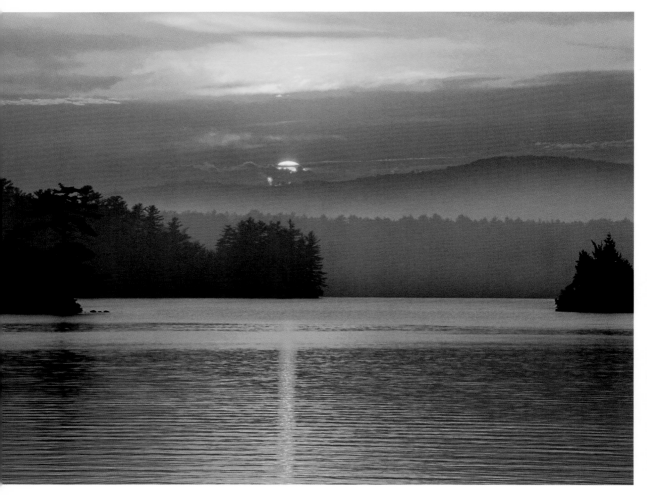

Sunset over Megunticook Lake

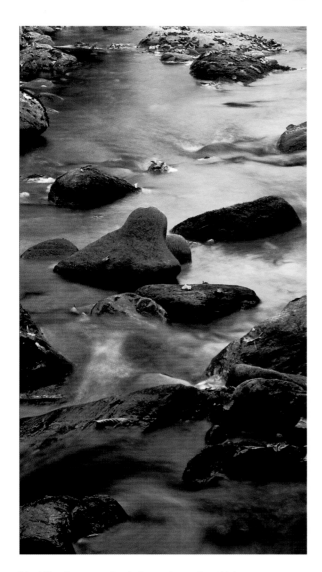

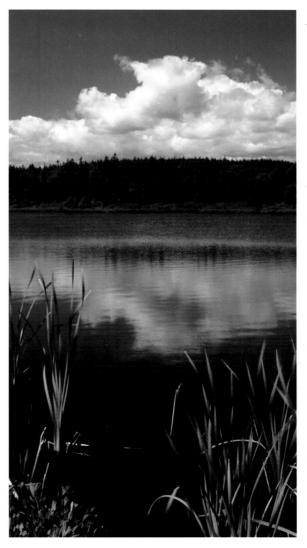

Mud Brook, a woodland stream in western Maine, near the New Hampshire border

Lagoon at Roque Bluffs State Park

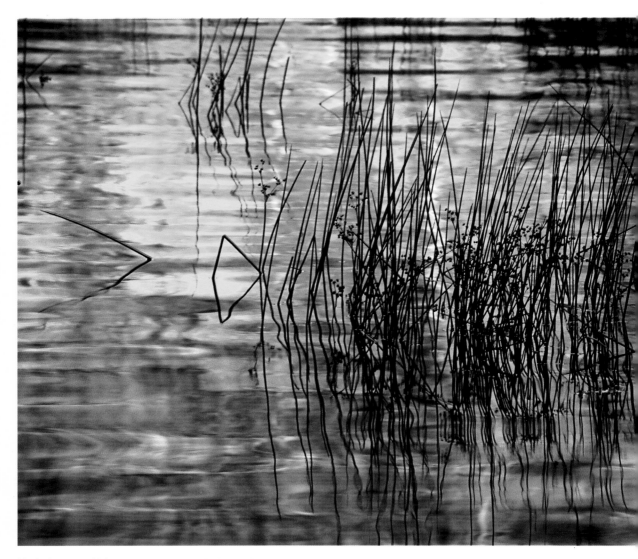

Vertical stems of lake grasses cross-hatch the rippled surface of Jordan Pond in Acadia National Park.

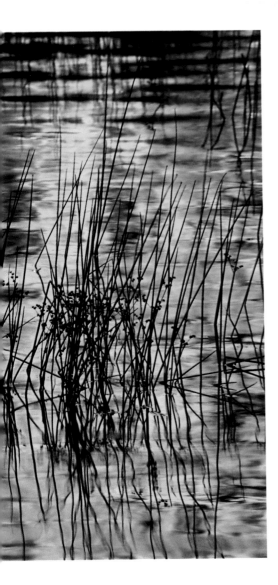

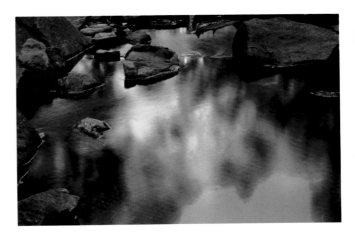

A splash of early fall color glints at water's edge.

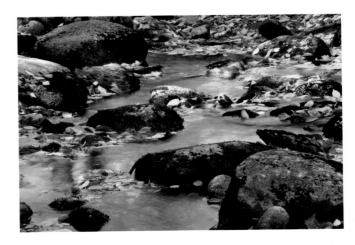

Autumn color is concentrated in Morrison Brook, in the
White Mountain National Forest.

49

S ea birds can be interesting subjects when their watery surroundings reflect their graceful forms.

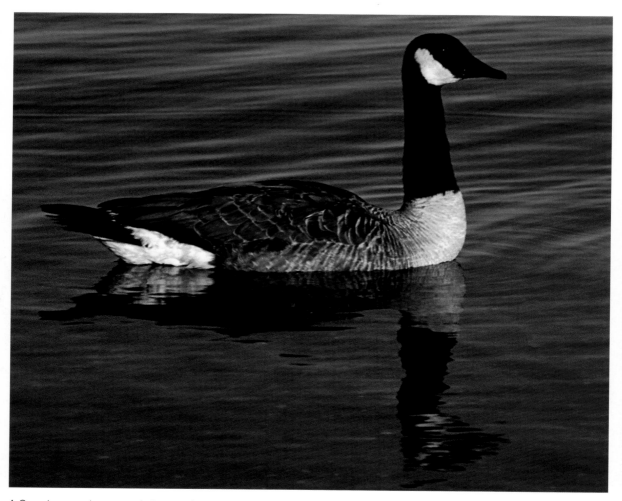

A Canada goose keeps an alert eye on its surroundings.

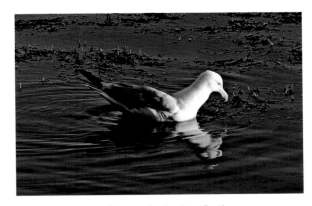

This gull appears to be questioning its reflection.

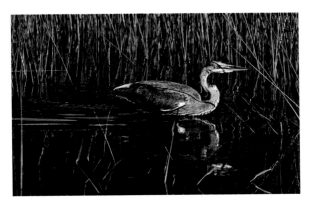

Long legs completely submerged, a great blue heron patrols a marsh at Acadia National Park.

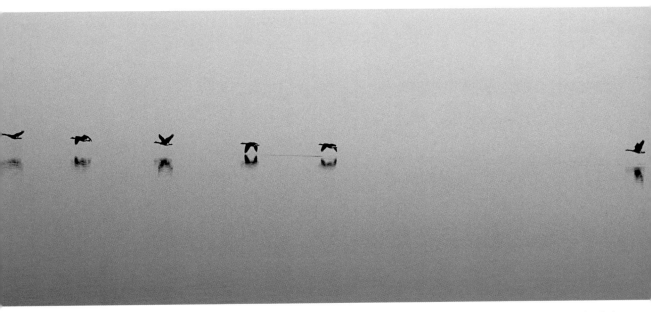

Geese taking off from Rangeley Lake

I n the aftermath of a rain shower, reflections are caught in places most people ignore or overlook.

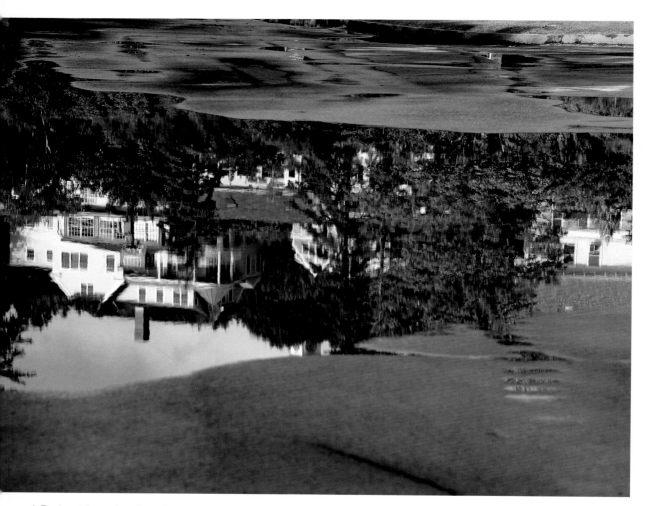

A Rockport home is reflected in water left by a summer shower.

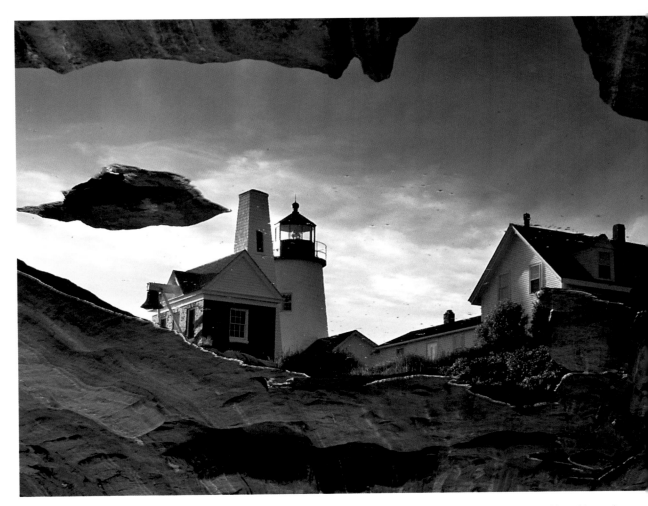

Pemaquid Point Light framed in a tide pool.

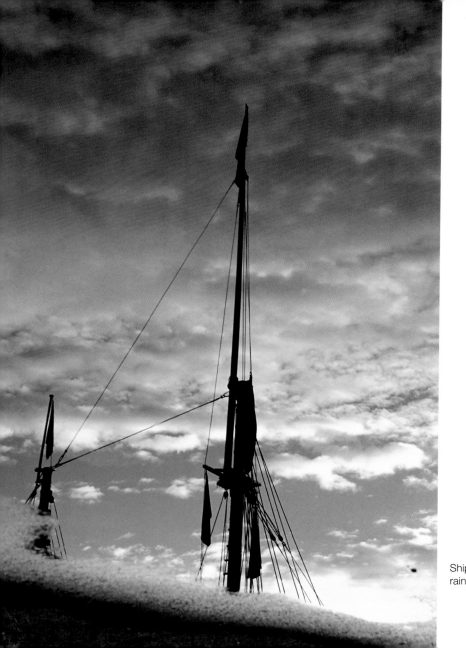

Ship masts reflected in a shore-side rain puddle

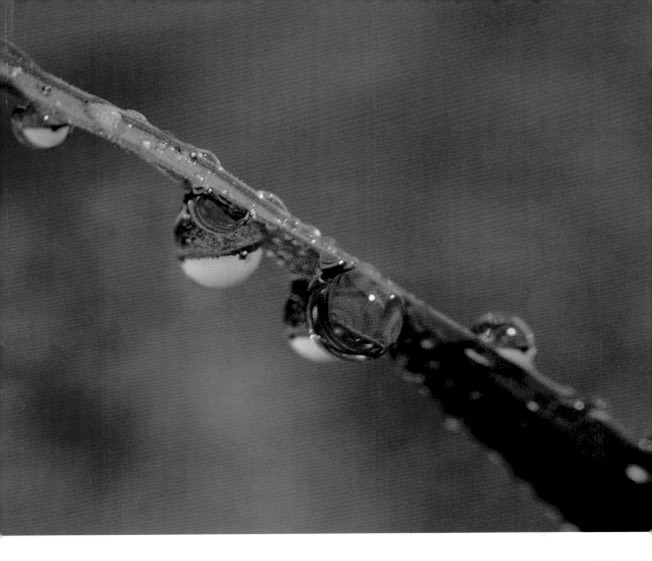

A water-drop lens on a blade of grass holds
a miniature vista of surrounding hills.

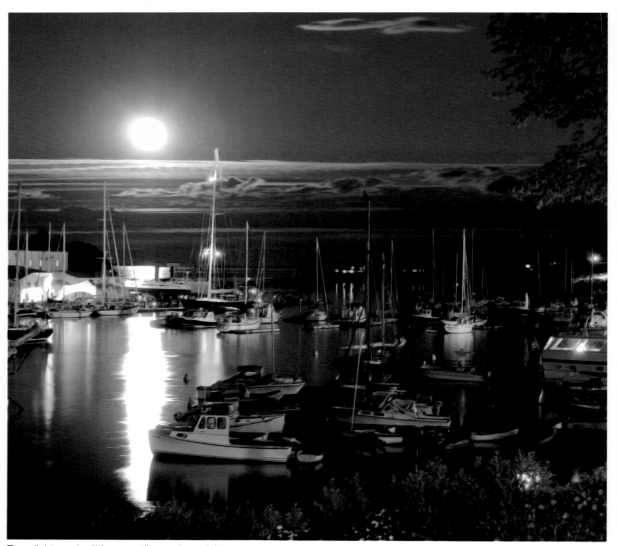

Town lights and a "blue moon" on a June night
illuminate Camden Harbor.